SEQUENCE

public invitation to participate in the energy trance mission
released 4/28/80

RECEPTION * FIRST PHASE * BEGINNING MAY DAY FOR THE
ENTIRE MONTH OF MAY 1980

being in a state of receptivity
 i am asking for offerings of positive charge
of your ever-favorite energy-endowed and
energy-inducing item of old clothing
 (the one you wear for luck and comfort
 the one you save for your safe keeping)

CONVERSION * SECOND PHASE * MEMORIAL DAY MAY 31, 1980

caring out the task together
concentrating the energy caught in the weave
considering the energy caught on this island
conceiving the spirit of compassionate care
we convert the clothes into bandage stripping
collecting the current and passing the power

CONDUCTION * THIRD PHASE * JUNE 1 — SUMMER SOLSTICE
 JUNE 21, 1980

so i am checking into this hospital island
to cure my karma and heal my hurt for good
3 weeks on ward's island tying 4,159 knots
in the tradition of the women from almost
everywhere who visit the healing waters to
pray and make supplications for health by
knotting their torn clothing into the trees

Donna Henes

ASTRO ARTZ, LOS ANGELES

Dressing Our Wounds In Warm Clothes:

Ward's Island Energy Trance Mission

Donna Henes

Photographs by Sarah Jenkins

15/99 Donna Henes Sarah Jenkins

DRESSING OUR WOUNDS IN WARM CLOTHES:
WARD'S ISLAND ENERGY TRANCE MISSION

published by
ASTRO ARTZ
240 South Broadway
Los Angeles, California 90012

Library of Congress Catalog Number: 81-65197
ISBN: 0-937122-02-5
first printing February 1982
printed in the United States of America

i changed the patients' names to protect their privacy.

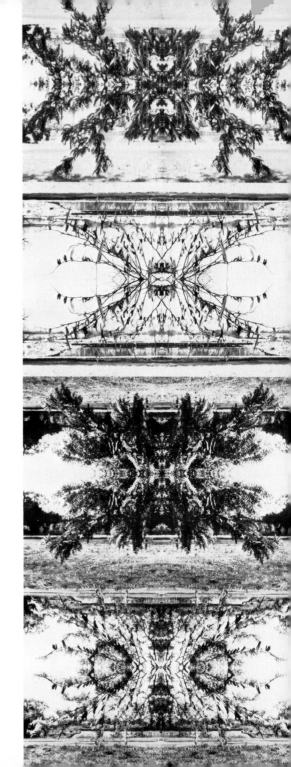

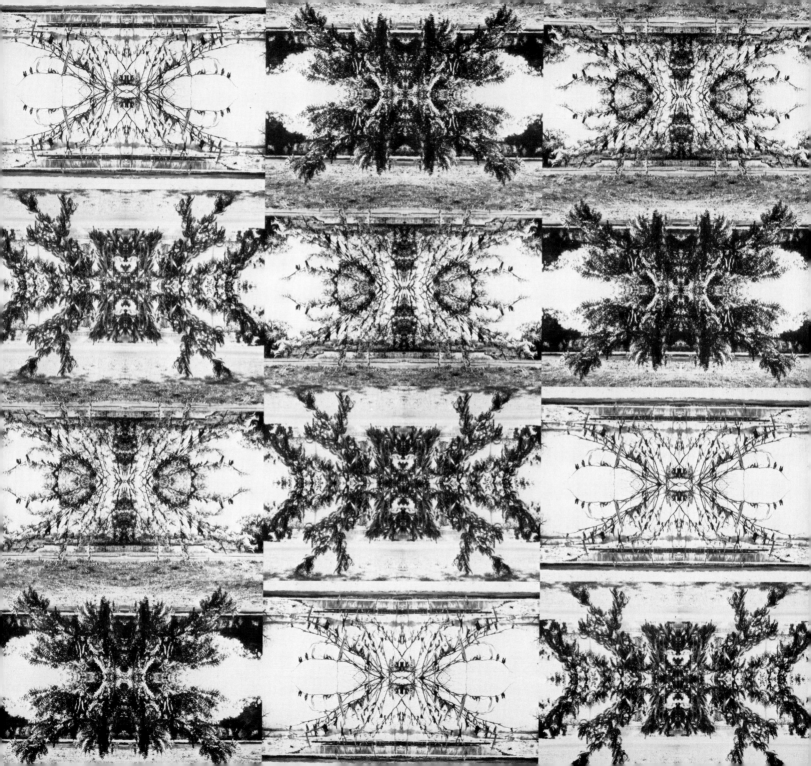

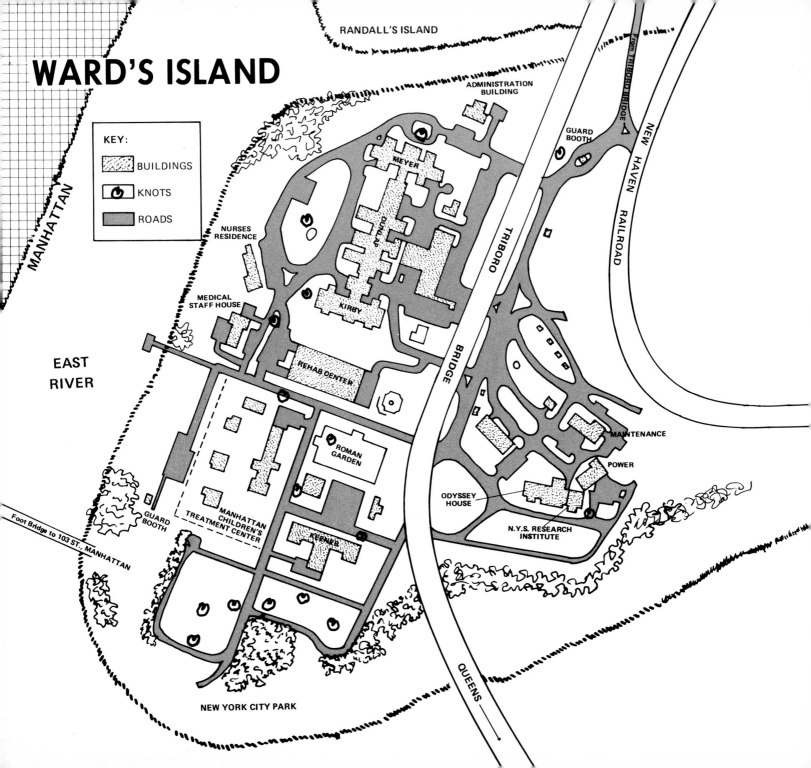

WARD'S ISLAND

RANDALL'S ISLAND

KEY:
BUILDINGS
KNOTS
ROADS

MANHATTAN

EAST
RIVER

ADMINISTRATION
BUILDING

From TRIBORO BRIDGE

NEW HAVEN RAILROAD

GUARD BOOTH

NURSES
RESIDENCE

MEYER

DUNLAP

MEDICAL
STAFF HOUSE

KIRBY

TRIBORO

BRIDGE

REHAB CENTER

MAINTENANCE

POWER

ROMAN
GARDEN

GUARD
BOOTH

Foot Bridge to 103 ST., MANHATTAN

MANHATTAN
CHILDREN'S
TREATMENT CENTER

ODYSSEY
HOUSE

N.Y.S. RESEARCH
INSTITUTE

KEENER

QUEENS

NEW YORK CITY PARK

FOREWORD

Donna Henes has given us a beautiful sculpture at Manhattan Psychiatric Center, our Ward's Island hospital outpost of civilization. These pages and their story are very much a part of it. As you read you will find yourself in the project and will be part of all of us and our various labors — patients and staff.

In a way, and without my knowing it, this perceptive interactive creation was one of the things I very much wanted when I arrived as the Hospital Director in February of 1977. There were three separate hospitals then, each in its own highrise adjacent building. I was brought in as the Superman-doctor who would unify the three and stop waste and corruption while saving money in an already inadequate budget. The honeymoon is long over now. The hospitals are unified. There have been savings. There have been many improvements. There is room for so many more.

Among the best of the improvements, if not the best (though this must never be publicly or bureaucratically acknowledged), has been the magnificent effort of so many people — patients, staff, volunteer artists — to upgrade the depressing environment indigenous to a midcentury, overlarge state psychiatric hospital. Had we all — you, me, society — been more humane in our approach to the mentally ill, there would not be a continuing use for that dreadful word "upgrade." But we never were, and still are not, so civilized. Large, ugly human warehouses still dot the land to store away the unfortunate people we still have not learned to handle. And when in our zealous anger we do away with these institutions, we find we really have not provided enough appropriate alternatives.

Manhattan Psychiatric Center is located on Ward's Island in the East River, less than halfway across the Triborough Bridge as it links Manhattan, Queens and the Bronx. It is really a part of Manhattan, and the little Ward's Island has long served the larger Manhattan Island very well. The acknowledgement of that service has never been generous. Manhattan Island must surely be one of the richest islands the world has ever seen. Consider its wealth and talent from almost any point of view. Look at its architecture, institutions, music, art, financial organizations, museums, and above all, human talent. It has always been too powerful, too busy to pay much regard to Ward's Island, which exists as a convenient location for the separation of the wounded and other undesirables from the ongoing interchange.

How could we on Ward's Island, without a budget for development of this kind, attract some of Manhattan's wealth and talent to help upgrade our hospital, while still going about our everyday, caring ministrations and duties? Especially crippling is the fact that we live in a fishbowl of criticism, the convenient but inappropriate scapegoat for society's failures in dealing with the mentally ill.

We were stumped by a convoluted, byzantine, constipated system, stymied by inadequate resources.

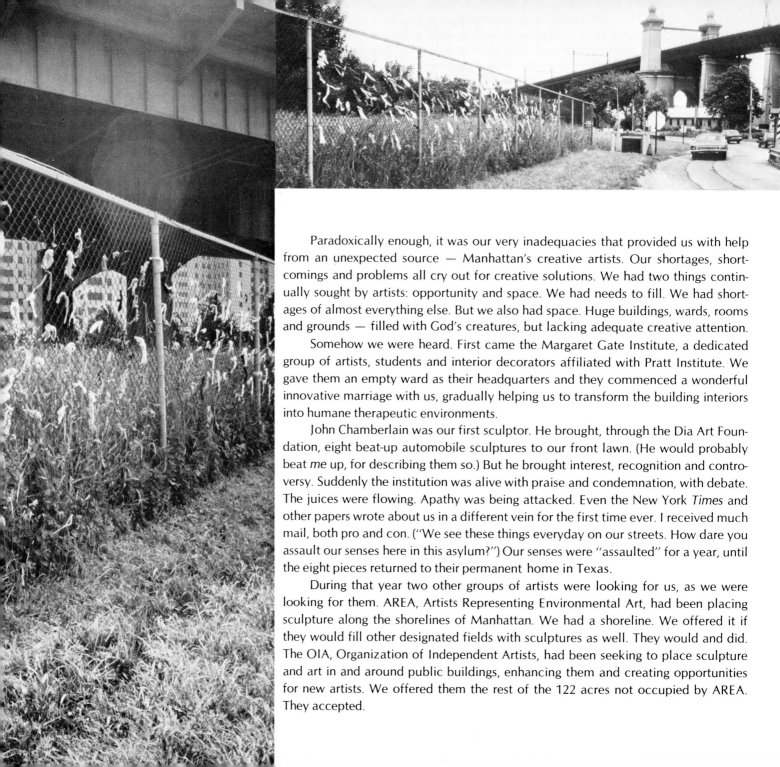

Paradoxically enough, it was our very inadequacies that provided us with help from an unexpected source — Manhattan's creative artists. Our shortages, shortcomings and problems all cry out for creative solutions. We had two things continually sought by artists: opportunity and space. We had needs to fill. We had shortages of almost everything else. But we also had space. Huge buildings, wards, rooms and grounds — filled with God's creatures, but lacking adequate creative attention.

Somehow we were heard. First came the Margaret Gate Institute, a dedicated group of artists, students and interior decorators affiliated with Pratt Institute. We gave them an empty ward as their headquarters and they commenced a wonderful innovative marriage with us, gradually helping us to transform the building interiors into humane therapeutic environments.

John Chamberlain was our first sculptor. He brought, through the Dia Art Foundation, eight beat-up automobile sculptures to our front lawn. (He would probably beat *me* up, for describing them so.) But he brought interest, recognition and controversy. Suddenly the institution was alive with praise and condemnation, with debate. The juices were flowing. Apathy was being attacked. Even the New York *Times* and other papers wrote about us in a different vein for the first time ever. I received much mail, both pro and con. ("We see these things everyday on our streets. How dare you assault our senses here in this asylum?") Our senses were "assaulted" for a year, until the eight pieces returned to their permanent home in Texas.

During that year two other groups of artists were looking for us, as we were looking for them. AREA, Artists Representing Environmental Art, had been placing sculpture along the shorelines of Manhattan. We had a shoreline. We offered it if they would fill other designated fields with sculptures as well. They would and did. The OIA, Organization of Independent Artists, had been seeking to place sculpture and art in and around public buildings, enhancing them and creating opportunities for new artists. We offered them the rest of the 122 acres not occupied by AREA. They accepted.

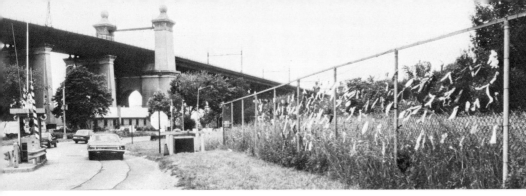
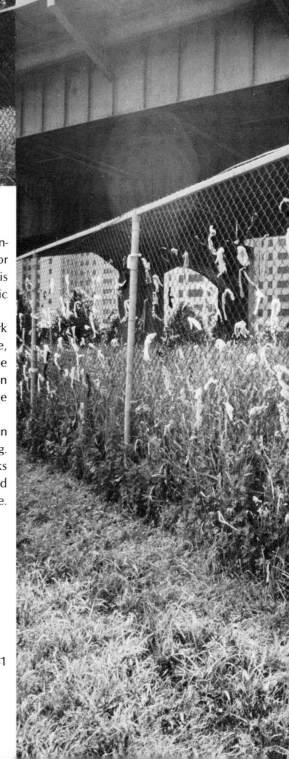

Within two years we had the first of several annual sculpture shows, with openings every spring. In the spring of 1981, with our new show of 110 major outdoor pieces, we had the largest sculpture garden in New York City. Of course bigger is not necessarily better. But who ever heard of such happenings at a state psychiatric hospital?

The best of our experiences has been the type which Donna Henes and her work epitomize. This is what we were looking for, and this is what is happening. Life, thought, interaction. The banishment of apathy and spiritual neglect which have so long been the fate of the most severely mentally ill. "Dressing Our Wounds in Warm Clothes: Ward's Island Energy Trance Mission" could almost be a capsule summary of our aspirations.

As a result of Donna Henes' work and energy, we have interested other artists in working with patients in various phases of their creations. And a response is growing. We have a staff and patients' sculpture committee. We have artists giving talks about their work. We have patients working with artists on the artists' sculptures and installations, and we have artists working with patients to create their own sculpture.

The experience has been good and meaningful. It has touched so many.

I hope it will touch you.

GABRIEL KOZ, M.D.
Executive Director, Manhattan Psychiatric Center
Clinical Professor of Psychiatry, New York University

December 2, 1981

ILLUMINATING THE SEEK WHENCE

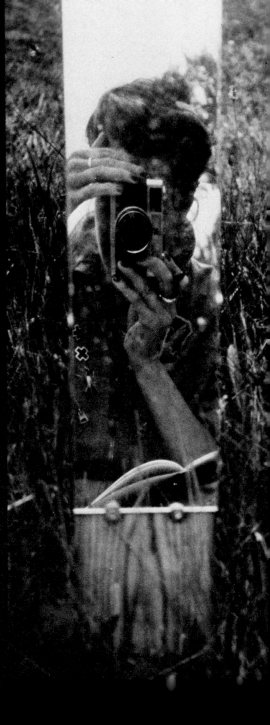

"thus in the beginning the world was so made that certain signs come before certain events." cicero

9/14/77 DREAM (at home)
am sitting at my green telephone table and i hear a bird shriek. i run into the studio to investigate. a little bird has flown into the loft and gotten stuck in the space where the two panes of glass of the open window overlap. it tries to fly through the glass and panics flapping up and down in its flat glass cage. i just reach in and pull it out and carry it to the fire escape. it flies off immediately. then turns around and flies back and lands on my shoulder. i send omar inside to get something to feed it. he returns with sunflower and sesame seeds on a pie plate which he offers to the bird. and instead of pecking at the seeds the bird picks them up with its hand and puts them into its mouth.

10/26/77 DREAM (in cleveland)
am carrying a clutch purse of black leather with all my valuables in it. the shiny leather of the purse keeps slipping on the soft bulky sweater i am wearing. and i keep dropping the bag. i drop it many times in increasingly difficult places: down a sewer gutter, out a window, etc. but i am always able, alone or with help, to retrieve it.

12/1/77 DREAM (at home)
am minutes away from doing amulet mandala with a group at a theater. am totally unready. at the very last second i am still winding the yarn into balls. i don't really have enough. the balls are all made of scraps pieced together. i start by walking around and around the circle breathing very deeply trying to find my center: trying to find the ritual space. my pacing is not meditative but frenzied. while i am circling some people stand up and start to leave. then i start talking about magic and knots but only from the surface and more people leave. then when it

comes time to tie knots there isn't enough yarn to go around. all in all it is quite poorly done and i know it with a very panicky feeling of drowning. afterward i am rationalizing to some man about why it didn't go well. but all the while i realize and accept that it was my own fault for being unprepared: unaware and out of control.

2/28/78 DREAM (at home)
i am in a used clothing store. on the bottom shelf under a table i find an old green jacket lined in orange. there is money in the inside pocket. i also find a long crayola-flesh-colored cape which is handknit and very shabby looking. but when i wrap it around myself it is soft and warm and secure.

9/30/78 DREAM (at home)
i am making a list of doctors all over the country because i am planning to interview all different kinds: old-fashioned country doctors, young hip altruistic doctors, american medical association establishment doctors and spirit healers.

4/28/79 DREAM (at home)
i am working in a tiny little room in the yard of a large estate. i am doing some sort of science stuff. i am keeping a detailed log. i am writing about the director and the staff. there are always power struggles. i am working on a project of unification. i collect hankies from people, wrap things in them and then disperse them again, giving them back to different people. on my rounds i stop in a small sharecropper's shack. the woman who lives there is on the table, naked, in pain, and totally absorbed in her own head and body. her husband tells me she is in labor. i soothe her. i tell him that they have to stop having babies or she will die. i tell her too. i tell her i love her. she moves toward me and i hold and comfort her. he looks shocked and i tell him that she understands.

that women know how to love each other. and she smiles at me. then i'm back at headquarters in the canteen having pie and coffee. mother is there. i tell her of my work. she says "it's the best job you've ever had."

12/14/79 DREAM (in tangiers)
i am seeing all my past dreams written and drawn on a very complexly illustrated manuscript scroll. i am looking through them to show mother all the healing dreams.

12/22/79 DREAM (at home)
i am a prisoner/patient in a russian insane asylum. my room is in the basement. i have two friends there. they are men and sometimes i am a man or maybe we change around. the guard room is right next to my room. and the staircase is just past the guard room. i plan to escape. and i do it by just simply walking up the stairs, out the back door and away. i am walking on the grass almost out of the yard when i feel a light hand on my left shoulder. i panic thinking maybe i am caught. but it is my friend who joins me and we both walk away together.

12/31/79 VISION (at home)
on the eve of the new decayed i conjure a vibrant image of the necessity for me along with like-minded people to spin sanity.

1/29/80 DREAM (at home)
a railroad crossing. the sign says truth.

5/18/80 DREAM (in manhattan)
i am in the used clothing store on myrtle avenue. my editor friend is there taunting me teasing me. she says in a very ironic and mock threatening tone "you will, you know. YOU WILL." there is a black leather jacket hanging there. i notice that the inside is soft grey suede.

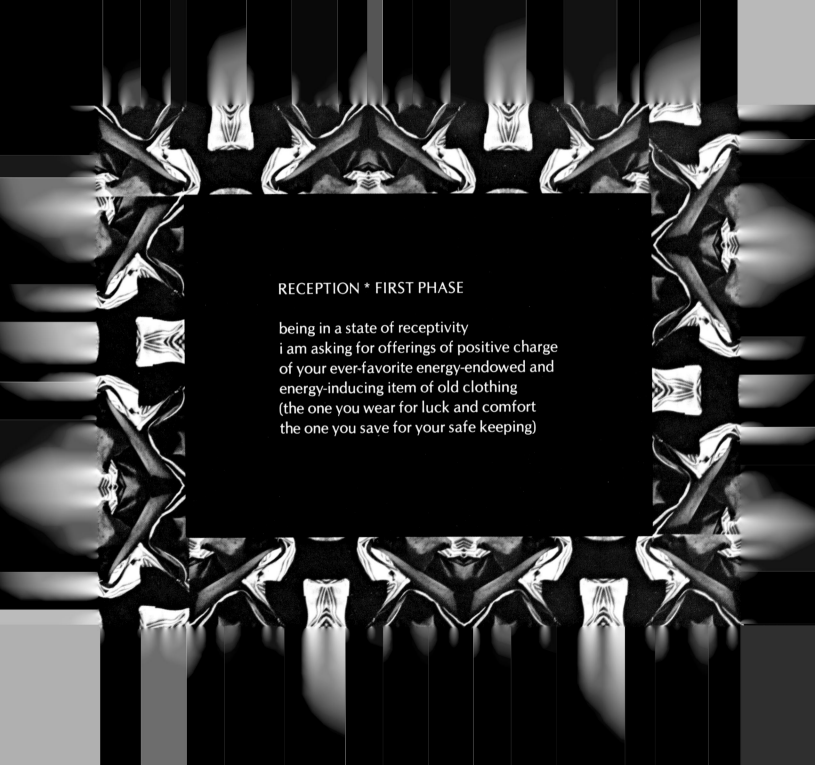

RECEPTION * FIRST PHASE

being in a state of receptivity
i am asking for offerings of positive charge
of your ever-favorite energy-endowed and
energy-inducing item of old clothing
(the one you wear for luck and comfort
the one you save for your safe keeping)

5/30/80

during the month of may people were invited to donate their favorite item of soothing lucky energy-filled clothing in receptacles placed at franklin furnace exhibition space, new york university and wbai radio. each box was seeded with offerings which i had received personally from friends. asking for donations for help represented a very important growth on my part because i finally realized that i can't go on giving away energy endlessly; that my feeling that i must generate it all alone by myself is a most macho assumption; that i'm not omnipotent. and so i acknowledged that i needed help; that i needed to receive energy in order to pass it on. so i took the chance and dared to risk asking for it.

on the night before the opening at ward's island, the second stage of the project, i retrieved the box from franklin furnace intending to pick up the other two in the morning. the carton at the furnace was fairly small and even so it was almost entirely empty. it contained exactly three items which i hadn't put in: two were from friends and one was a wonderful offering sent by a stranger by mail. i knew that i had taken a huge chance but this non-response was shocking. terrifying . torturous. a nightmare of rejection come true. how can i keep continuing? i must be mad. how can i have thought that my concept was so clear when no one understands it? and if they do understand, but reject it, how can i sustain my faith in the worth of my work? how can i be right and the whole world wrong? that's crazy isn't it?

and how especially painful considering that the entire continuing all-encompassing character of my work has always been the concept of cosmic connectivity: my web-on-the-brain way of seeing everything. it's as if my complete sense of connection is being called into question. i am suffering from a really desperate need for self-evaluation: a clean critique.

i spent the rest of the night crying into my rum.

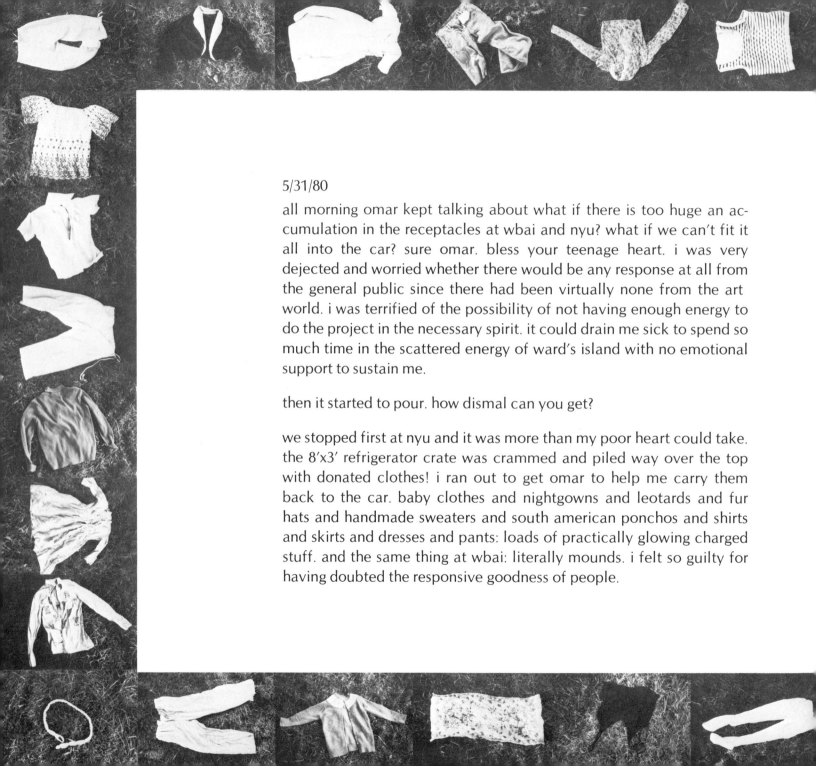

5/31/80

all morning omar kept talking about what if there is too huge an ac-
cumulation in the receptacles at wbai and nyu? what if we can't fit it
all into the car? sure omar. bless your teenage heart. i was very
dejected and worried whether there would be any response at all from
the general public since there had been virtually none from the art
world. i was terrified of the possibility of not having enough energy to
do the project in the necessary spirit. it could drain me sick to spend so
much time in the scattered energy of ward's island with no emotional
support to sustain me.

then it started to pour. how dismal can you get?

we stopped first at nyu and it was more than my poor heart could take.
the 8'x3' refrigerator crate was crammed and piled way over the top
with donated clothes! i ran out to get omar to help me carry them
back to the car. baby clothes and nightgowns and leotards and fur
hats and handmade sweaters and south american ponchos and shirts
and skirts and dresses and pants: loads of practically glowing charged
stuff. and the same thing at wbai: literally mounds. i felt so guilty for
having doubted the responsive goodness of people.

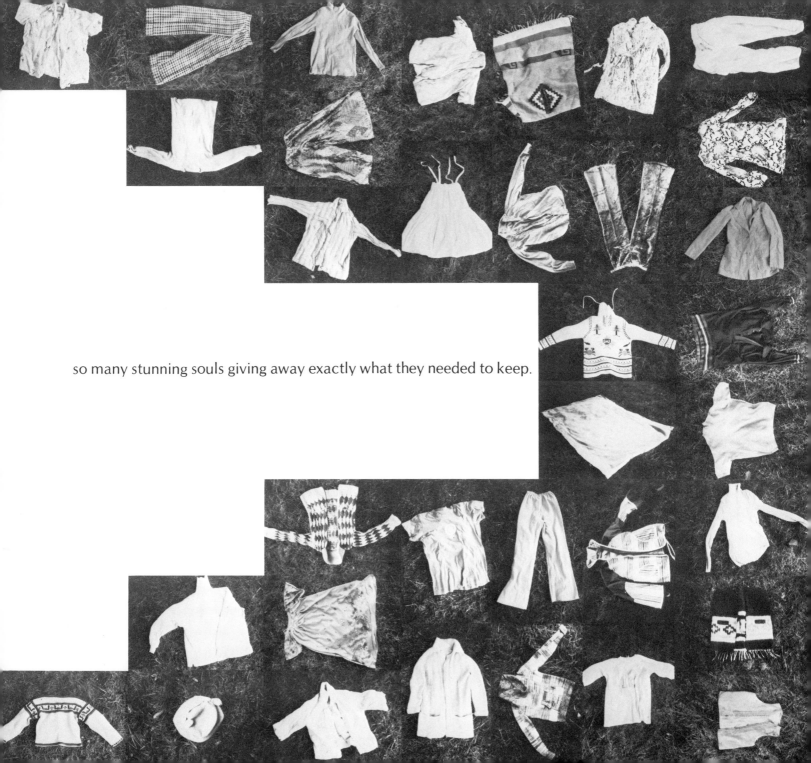

so many stunning souls giving away exactly what they needed to keep.

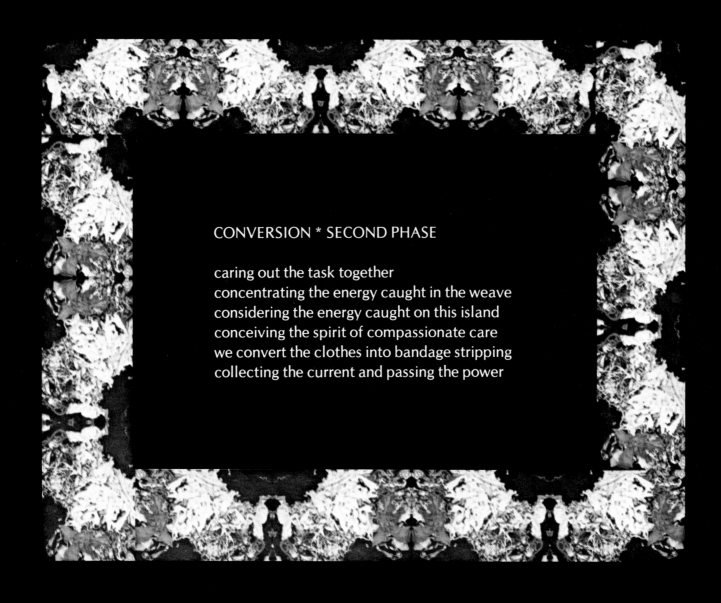

CONVERSION * SECOND PHASE

caring out the task together
concentrating the energy caught in the weave
considering the energy caught on this island
conceiving the spirit of compassionate care
we convert the clothes into bandage stripping
collecting the current and passing the power

5/31/80

it continued to rain all day so i set up under a tree on the staff house lawn. i piled all of the collected clothes onto the grass. sarah photographed each item one at a time: loving portraits. i passed out project descriptions and also healing water which i had brought back from a shrine at caravaggio near milano. it is said that the virgin appeared to a peasant woman there and when she disappeared a rose bush grew in the middle of the stream where she had stood. and ever since the water has contained curative powers.

the president of the patients' group approached me and introduced herself. she told me she was catholic and understood such things. she carried around the water which i had mixed with sandalwood oil and annointed people with it as she explained my concept to them.

we all sat under the tree nestled together like puppies in the pile of clothes, investing the cloth with our energy at the same time as we were drawing energy from it. we spent the day memorial day shredding the fabric, processing the clothing into bandage stripping in the memory of all the women who had torn all the bandages for all the wars all through time.

a woman announced that she was the president of the group of friends and relatives of patients and she attacked me summarily for destroying perfectly good clothes when i could have donated them to the patients. i tried to explain that i felt i was donating something just as important. i tried not to lose my patience. then some man stepped in and talked about the value of non-material considerations. i wondered why it didn't occur to her to question the worth of the "real sculpture" on the island. i mean how many xray machines can never be built due to the waste of metal in those pieces? let alone all that good wood and concrete?

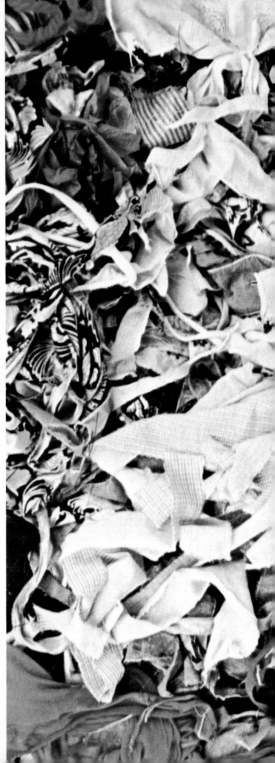

a young filipino patient named philip joined us to find out what we were doing. i started to explain and before i had even finished he grinned "oh, sure, i get it" and grabbed a shirt from the knapsack he was carrying and tore it immediately into shreds. and then he ripped up the knapsack too and dumped the strips into my lap and split. that one frenetic act of faith alone could carry me for a week at least.

and we tore on, caring out our task. and this contemplative work worked up in all of us all of our associations.

two separate people told me about gorky who had painted and written about the custom of women in his native armenia who visited the healing waters. they decorated the trees with knots made from strips of their clothing torn on the spot. and then they danced and rubbed their breasts against the bark of the dressed trees.

a visitor from ireland told of such knot-hung trees which are common near magic wells in his home county. i told about the knotted palm trees that i had seen in the oasis at sidi harazem in morocco. the fronds

themselves were knotted and covered with hundreds of cloth and yarn knots by visiting women. my friend mohammed held down a tall branch for me and i added my knot of red fluorescent ribbon which i use in my own tree tranceformations.

this custom of women going to the sites of healing waters to tie knots of supplication for fertile and healing energy on the surrounding bushes and trees is still common throughout north africa, the middle east, the far east, central america and the british isles. a practice so widespread would indicate a onetime universality.

jeannette, a patient about my own age, talked about not having been able to make it as an artist, about her lack of stick-to-it-iveness. oiy. she is very interested and involved with the arts and artists on the island.

helen thomas, the dynamic and productive-in-the-face-of-all-odds public information person at manhattan psychiatric center who co-produced the sculpture garden, talked about how typical it was that she picked a heavy lined coat to tear as it was impossible to do!

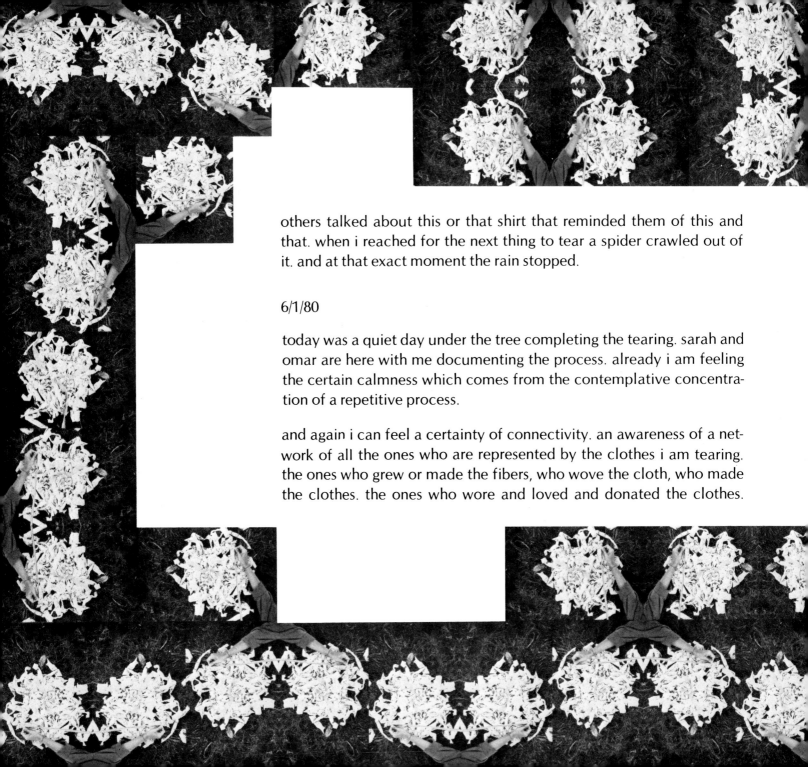

others talked about this or that shirt that reminded them of this and that. when i reached for the next thing to tear a spider crawled out of it. and at that exact moment the rain stopped.

6/1/80

today was a quiet day under the tree completing the tearing. sarah and omar are here with me documenting the process. already i am feeling the certain calmness which comes from the contemplative concentration of a repetitive process.

and again i can feel a certainty of connectivity. an awareness of a network of all the ones who are represented by the clothes i am tearing. the ones who grew or made the fibers, who wove the cloth, who made the clothes. the ones who wore and loved and donated the clothes.

and also the ones who maintained the clothes, who kept a continuing contact with them, who cleaned them and smoothed the wrinkles out. i am revelling in an understanding of family and continuity and maintenance. and now the web expands to include the ones who furthered the process by tearing the clothes into shreds. and the ones who will help to tie the knots.

and now i have a great mass of strips to use for knotting the trees as well as a huge reserve of untorn clothes. and i have a vacant room in the staff house to keep them in and work out of: a headquarters and retreat for the duration of the installation period. i need such a place so i won't have to hassle anyone by storing my piles and boxes in an office. my room is a perfect nun's cell with a bed a desk a bathroom and a view of the east river. it will be wonderful to have a place to gather and concentrate my energies.

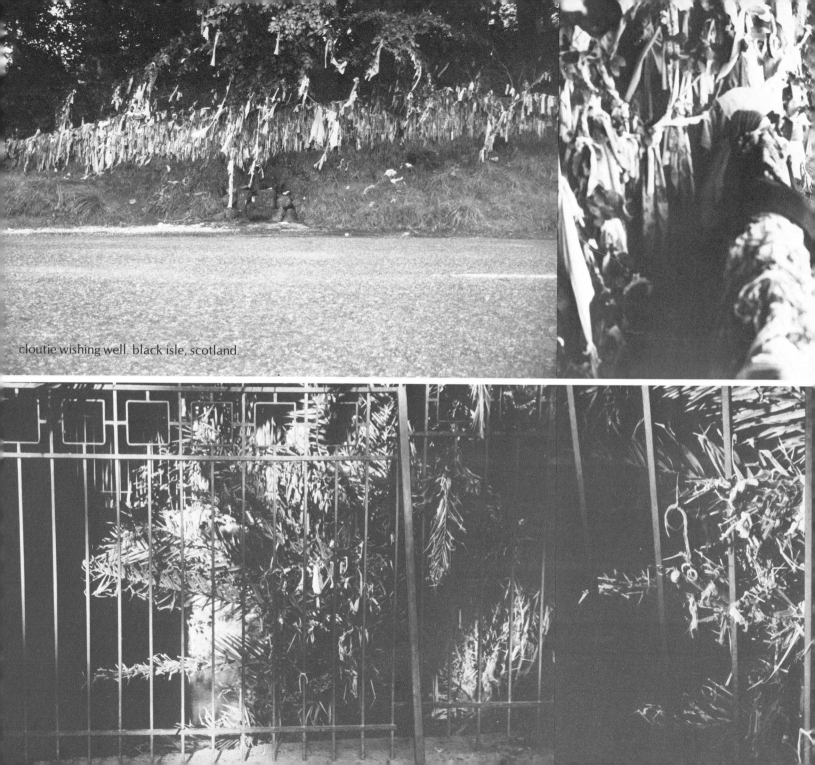

cloutie wishing well. black isle, scotland.

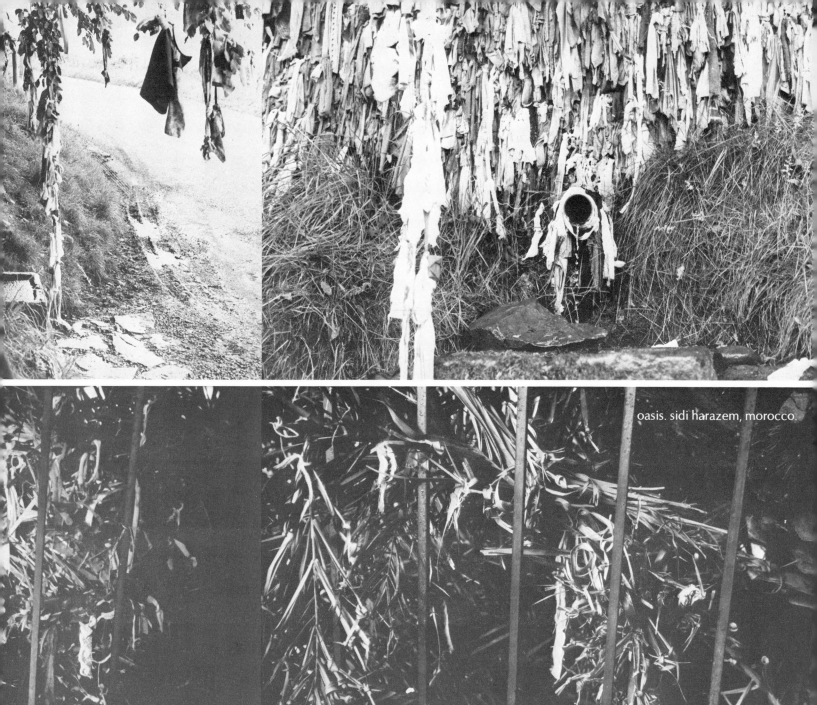

oasis. sidi harazem, morocco.

CONDUCTION * THIRD PHASE

so i am checking into this hospital island
to cure my karma and heal my hurt for good
3 weeks on ward's island tying 4,159 knots
in the tradition of the women from almost
everywhere who visit the healing waters to
pray and make supplications for health by
knotting their torn clothing into the trees

6/4/80

i stayed home for two days collecting myself and the things that i needed to take to the island. i finished up some business obligations so that i could be totally free and clear. no nagging thoughts to distract me.

so i arrived this morning elated and excited and ready to apply my whole self. i stopped at my room to collect a bag of strips, then drove out to the far meadow to spend the day in solitude to establish myself.

for the first site i chose a huge and old wide-spreading tree in the center of the high grass field even though in general i plan to work in very visible locations in full view of anyone who passes by. it seems obvious that in order for the magic of the energy trancefer to work i must be absolutely accessible and open to everything. but first i have to center myself in order to be certain.

i sit here half in shade half in sun with all my belongings for the duration, all that i will need or use spread on my blanket which is spread under the tree. of several possible blankets i chose to bring this one but for no immediate apparent reason. only now do i realize that its red blue and yellow weave with black and white details represents the totality: the potential: the essential basics from which all possibilities emerge.

i am wearing my old air force jump suit. the same one i wore to make my first outdoor web, the first in the spider woman series of process environmental sculpture. the same i wear to do most of my public work. it is associated in my mind with jumps/leaps in my creative consciousness. it is all i am wearing or will wear for the rest of my involvement with this endeavor. it gives me courage.

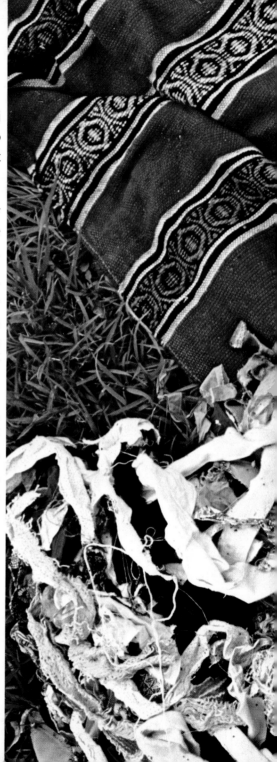

it is completely threadbare by this time and each time i wear it i have to repair it. so it is festooned with patches of velvet and satin and embroidery, each from something which i remember well. on the back i have attached an extremely old piece of crochet work that anne gave me: a pattern of red roses connected by a spider web. on the front i am wearing a spider pin purchased at a yard sale. next to the spider are two red cross pins which i found in a trunk in the street which contained the fond keepings of a woman's life. i still keep her archive for her and the only things which i removed and use are these pins and her ivory letter opener.

in my woven basket i carry this notebook, a camera, a rose-and-bird-painted thermos filled with coffee, project descriptions, grass, healing water/oil, scissors and counter. previously the counter counted the 980 some people who blew up the big apple hot air balloon in my bicentennial inflation project. and now it will count 4,159 knots for so many patients, staff and visitors on the island.

this first tree is for me. on it i have tied 65 knots representing my numerological birth number using only those strips which came from the clothes of my friends. with each knot i recalled the story related to me of its preciousness. also i thought of the people who called me to explain that after thinking deeply they realized they could not bear to part with their special thing.

after attaching the knots, i lay under the tree to look at them. until this moment i had not considered too deeply exactly what the knots would look like in the trees. the trailing tails of the knots mesmerized me and i spent more than three hours watching them. i was levitating, not awake or asleep, just sort of floating above my body just below the fringed branches.

after getting up i spent the rest of the day driving around the island, up and down every path, choosing the sites i would work in. i was also searching for old knots which were already in the trees. they were tied over a ten year period by a patient who used anything he could find: socks, plastic torn from garbage bags, shoe laces, rubber bands, twist ties, electric wire and clothing. i can't imagine how many knots he left on the island but they are everywhere i look. i am absolutely drawn to his knots. each time i become attracted to a particular tree and approach it i find that sure enough he had been there first.

this is such a strange place. the entire island is a virtual garbage dump which houses actual and human waste. there is a dump and training site for the sanitation department and a projected raw sewage storage facility as well as facilities for mentally ill adults, retarded children, alcoholics, drug addicts and bowery bums. in addition and ironically it is a protected bird sanctuary which is teeming with cardinals, pheasants, red-winged blackbirds, orioles, huge robins, all sorts i don't know and the fattest pigeons i have ever seen. and thousands of cotton-tail rabbits.

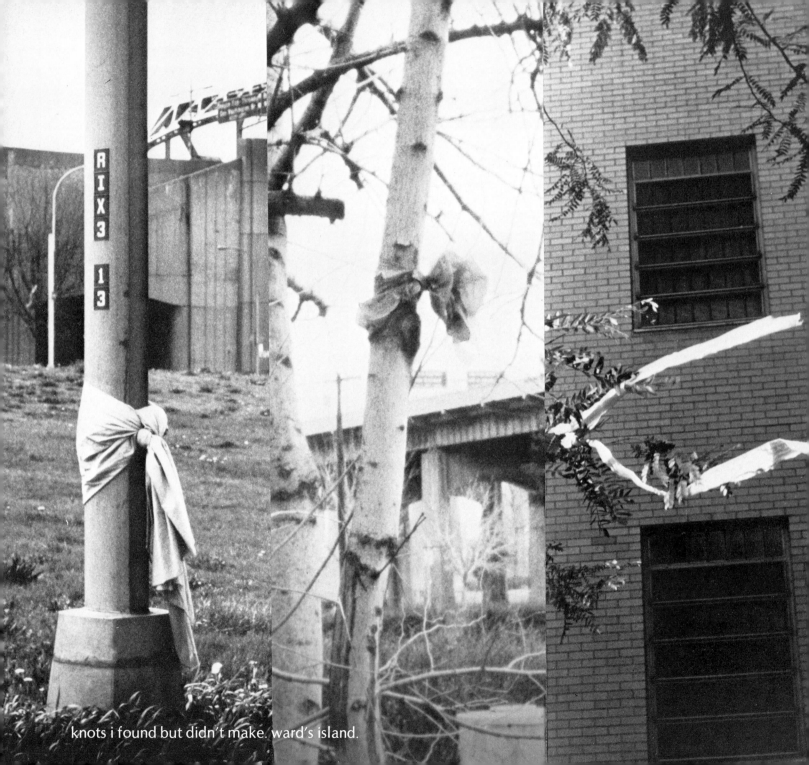

knots i found but didn't make. ward's island.

today there was a conference on dangerousness here. i suppose it's needless to say that most of the visiting psychiatrists and counselors assumed that i was a patient and safely ignored me. i mean who else but a crazy person would spend a whole day tying rags in the trees?

i was working on a small tree next to the staff house when a doctor visiting from coney island hospital came over to talk to me. i told him that i had chosen to work on this tree because there were already five knots in it and i took that as a sign. he told me that he had recently become interested in trees and that this one was a linden or basswood. he was amazed and delighted as i pointed out the original knots and talked about the universality of the magical connotations of knots. i talked of knots used in prayer practices: talises and rosaries and prophylactories and buddhist and voodoo ceremonial knots. i told him that i thought that knots were such primal symbols because all people wear them always. the navel, after all, is a cord cut and tied. he left very intrigued and returned shortly giggling with excitement and took me on a tour of all the knots he had scouted in the nearby trees. then we tied knots together.

a passing doctor asked for advice about how to save his dying pear tree, thinking i was a tree surgeon.

a security guard talked to me about the patient who had tied the knots before me. he said, "you know he should be getting paid to do all this instead of you." and i agreed. but i did inform him that i was not getting paid. i told him that i was photographing all the knots i found and that i would love to meet this man. he told me that he was now in a halfway house in queens but that he's much worse off there because there are no trees. he just sits on his bed all day and is interested in nothing anymore. i asked him to try to track down the man's name and where i could find him.

a psychiatrist, dr. lopez, spent a good deal of time asking me about folkloric customs concerning knotting and magic and healing. we

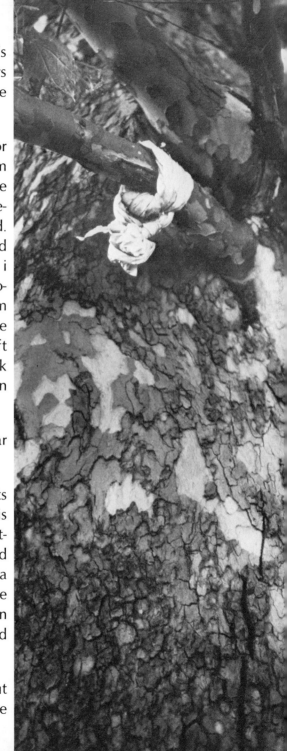

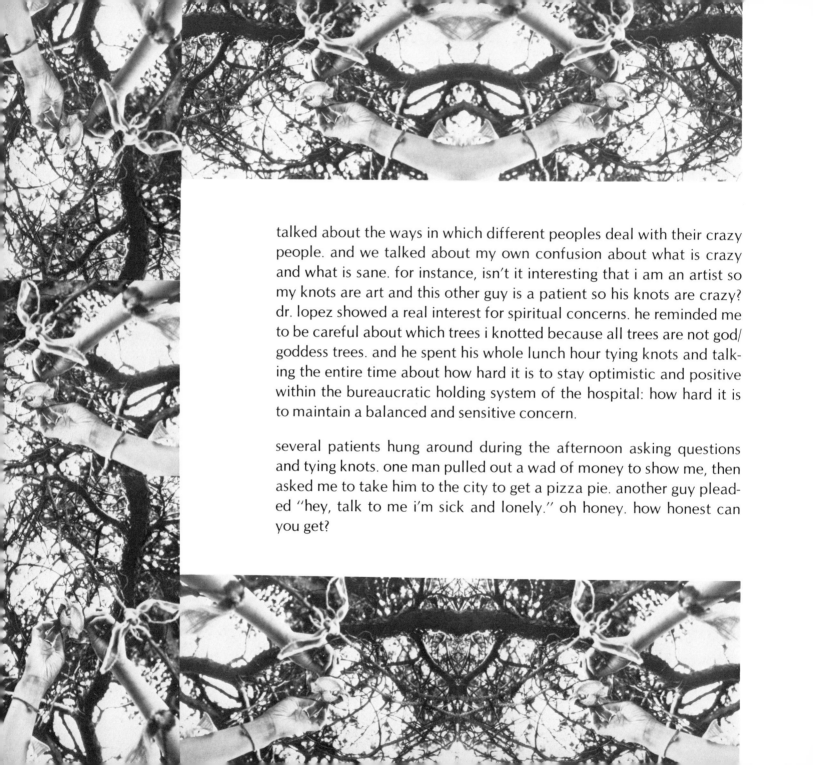

talked about the ways in which different peoples deal with their crazy people. and we talked about my own confusion about what is crazy and what is sane. for instance, isn't it interesting that i am an artist so my knots are art and this other guy is a patient so his knots are crazy? dr. lopez showed a real interest for spiritual concerns. he reminded me to be careful about which trees i knotted because all trees are not god/goddess trees. and he spent his whole lunch hour tying knots and talking the entire time about how hard it is to stay optimistic and positive within the bureaucratic holding system of the hospital: how hard it is to maintain a balanced and sensitive concern.

several patients hung around during the afternoon asking questions and tying knots. one man pulled out a wad of money to show me, then asked me to take him to the city to get a pizza pie. another guy pleaded "hey, talk to me i'm sick and lonely." oh honey. how honest can you get?

after doing several hundred knots on trees next to the staff house and kirby building and talking for hours with an unending stream of people, i had a terrific need to be alone for a while before finishing for the day. i returned to a site that i had chosen yesterday: swinging low branches like a parasol shading the road. i worked happily there for quite some time, recovering from so much close exposure. this knot tying will take much longer than i had expected if i remain open to having conversations with anybody who approaches me. and this is key i think. i cannot allow myself to lose sight of the purpose of this project no matter how long it takes.

while working hidden in the hanging branches i noticed a pheasant fly into the field and then walk to the far end of it. i grabbed my camera and tried to follow it very quietly. i wasn't quite quiet enough and it flew away. but there on the bush where it had led me was a huge bulky knot tied from a powder blue insulated undershirt. really fantastic. so

to honor my colleague i tied several knots around it, accenting it and attempting to draw energy from it. it was a very obscure site and i had planned to stay obvious and visible along the pathways, but i simply had to celebrate my friend's previous presence.

who is this man? i am dying to know what it was he was trying to do. what it was that he knew that i do too.

sarah came to photograph what i had done so far: five knotted trees. i drove her around to all my sites and then she and omar and i spent the rest of the day looking at all the other sculpture on the island.

i must say that most of the work in the sculpture garden disappointed me terribly. the majority of the work is not site-specific. as a matter of fact most of it was obviously manufactured indoors and just placed any old place. many of the pieces would look much better inside. and indeed many had already been exhibited in gallery situations.

but the thing that really horrified me was a sort of overall esthetic of tortured violence: so many sharp jagged edges. is this the anguish of the artists i wonder, or some concession to the stereotyped snake-pit image of mental institutions? certainly an artist can't work to please

a particular audience, ignoring her/his individual personal vision. but on the other hand it seems that very few of the artists paid any consideration at all to the needs of the people here who have to live with the work. there is so very little to soothe the soul. and so much to stimulate a very disturbing agitation. there are even a few pieces you could commit suicide against.

and it seems that almost as little sensitivity was shown in terms of respecting the environment of this island. the worst example of which is the artist who poured concrete into what he had been informed was the favorite nesting ground of several species of birds in the protected sanctuary. i don't know why this should hurt me so much. it's not that i am really surprised. it's just that it's too late for all this negativism.

6/10/80

i spent a good deal of time today in dunlap and meyer buildings; in the cafeterias, lounges and in helen thomas' office. in an obvious attempt to make the hospital more cheerful, and in a probable reaction to institution green, the interiors of the buildings are painted in amazing and dizzying color schemes. i'm sure this was done with every good intention but the result makes for a very frenetic environment. purple doors

in orange frames opening into blue and pink corridors with green trim and every other possible imaginable color combination. too too much.

this is especially interesting because i notice that an extremely tiny percentage of the donated clothing is brightly colored. practically everything which people considered to be soothing calming healing and lucky is either light or neutral in color. the majority of the strips are pale pastels or blues greys creams and whites. they are very diverse in terms of pattern design and weave but they are very similar in the gentleness of their tints. there are also a lot of muted more deep and somber tones: maroons and purples and rusty oranges. but there are only two really red things and only one bright pink. nothing very intense.

i spent the afternoon working on one large tree in the middle of the lawn in front of dunlap. under its widespread low hanging branches are many brightly painted picnic tables. it is a center of patient congregation. all of the time i was working, an older woman who was indistinguishable in type from the street bag ladies sat next to me on one of the tables. she was communing with the birds. it didn't appear that she was feeding them or talking to them. but she sat there for hours surrounded by and occasionally covered with pigeons.

a young black patient yelled across the lawn to ask what i was doing. i answered that i was tying one knot for every patient, staff and visitor on ward's island. and he screamed "great, tie one on for me." "ok, this one's yours!"

for the longest time a middle aged white-coated man stood watching me from the building steps. he finally came over and we talked for several hours. we mainly talked about art, as he used to study at pratt institute and is interested in keeping up with all the latest developments. he is still an avid photographer. dr. epstein said that my knots reminded him of the calligraphic scrolls that poets and petitioners hang from the trees in japan. i relate strongly to that image. these knots are my silent mantras: prayers for peace. he was shocked that my goals were not strictly esthetic and the spiritual nature of this piece really surprised him. he wondered if it was really art.

this conversation made me realize just how few esthetic decisions i have been making; how much esthetic control i have forfeited. because people gave whatever item of clothing they wished and because the choice was based on spiritual value, i have no control as to the color or texture of the knots. because people tore the clothes however

they pleased, i have no control as to the size of the strips i have to tie with. because anyone who wants to is tying knots with any strips they choose and anywhere they want, i have no control as to the shapes of the knots or their placement. the only firm decision i have been making is the choice of each particular tree.

this sculpture is not the art, but the result of the art: the facilitation of an emotional tranceformative process witnessed only by the participants. the sculpture is the physical visual record of an experience and the reminder of a reason. it's not that it doesn't matter if it looks good but that it *has* to look good by virtue of the way in which it was accomplished. as gramma used to say "so, how could it be bad?" so much good energy....

it's wonderful to watch these calm peaceful strips of people's lives hanging blowing waving in the wind. they are very unobtrusive, even difficult to distinguish from any distance. but once getting a glimpse of them they are incredibly inviting, even mesmerizing. it's as if they are shivering with the awareness of the special spirit they contain.

6/12/80

the site today is an abandoned building with broken windows and broken overgrown stairs. the entrance is flanked by two giant bushes. one is very thick and luxuriant, the other dead and bare. it took all day to do 400 knots on the dead side which seemed to cry out for adornment. omar did more of his video tape, dr. epstein brought me his clothes donation and took pictures. and dr. lopez brought the art therapist to join me in the tying.

the building is across the road from the manhattan children's treat-ment center and all day small groups of boys trooped over to find out what i was doing and to help. it was a very intense time of paying at-tention and explaining and listening: drawing them in and drawing them out. i wonder if there are only boy patients here? one boy asked if i made a wish for each knot. i do. a wish or dream or memory. after the last of the boys had gone, there remained on the steps a small ital-ian handworked wooden cross covered in tin. a sign of the tree left magically for me.

some nurses stopped by. they were black and related very strongly to the idea of tying knots for luck. and so they all tied several.

a visitor to the sculpture garden stopped to tell me that i looked like my knots. he is an illustrator and i suspect that he was referring to my much patched space suit and the five colored combs in my hair. but if i don't really look like my knots, i am sure becoming tranceformed by the tying of them. the caressing and thinking and fantasizing of them.

6/14/80

when i stopped by the staff house to get my things this morning i noticed that all the knots except for a very few at the center had been removed from the staff house tree. i was confused when i saw that the knots were not scattered on the ground, until i noticed that entire branches had been sawed off. this was immediately frustrating and very disturb-ing. but the more i stared at it, i began to realize that the alteration of this tree was an improvement. it is so much more lovely and powerful

wearing only the belt that terry's mother had knotted and rosemary's blanket from her days as a mental patient when she was in mourning for her lover. clearly these remaining ones were just too powerful to touch. and they are so beautiful, just these few strips hanging on.

soon sarah arrived to continue her documentation project and we took a tour of the trees. when i went to point out the shirt bush i couldn't find it. it wasn't where it had been. i realized that it must have been cut down too. sure enough, we found the pile of branches on the ground and buried among them were the shirt knot and the ones i had tied near it. i was surprised that my reaction was so calm. these destroyed knots suddenly seemed justified to me. i began to see that if indeed each knot represents each of these people, then surely these fallen ones must be for the casualties. there are so many people here on this island who don't make it. there are the patients who literally spend the rest of their lives here only to be carried out: processed in the island's own morgue. and then there are those on the staff who are here because they can't make it anywhere else, like the caribbean male nurse who has lived in the staff house for 32 years. i did make these knots and nothing can deny that. and now the process has just progressed another step and nothing more sinister than that. somehow everything seems ok here. and maybe that acceptance is what i am here to learn.

i set up work on a very old scraggly pine tree with many low and dead branches. some branches are so sad that they just seem to need attention. and these dead branches allow the knots to be more visible as well. the tree is at the edge of what they call the roman gardens and is one of the more spectacular sites. a young manchild named sonny stayed and worked with me for a very long time. we didn't talk much, hardly at all. we just knotted calmly and contentedly side by side.

a couple who could have been patients or not stopped and watched for a while, asking no questions. a definite patient came by to ask sarah to take his picture because he is on the ny yankees.

before leaving i drove by all the sites once more. i noticed how sparse the collections of knots seem after not having seen them for a while. i work on each tree until it seems very dense to me; actually until it becomes claustrophobic. but always when i return, they seem to be much less crowded. but i love how they look like giant tiffany lamps with their multi-colored knotted fringes.

6/15/80

sarah came back today and so did omar. while sarah photographed the cut down branches omar helped me to climb a bit higher to fill in the branches hanging over the road. mainly i wanted to thicken up the

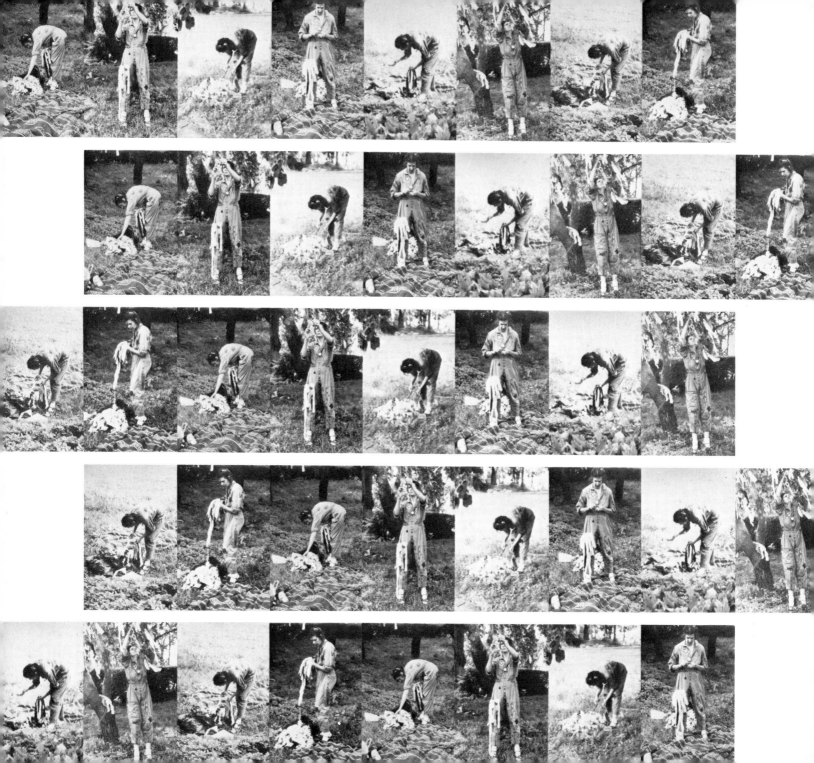

appearance rather than to go much higher. i want all of the knots to be at or just above eye level. i want the entire effect to be human in scale. and i don't want them to be hidden in the interior branches but to hang from the lowest ones so they are free to play in the wind.

i spent this quiet sunday in a tree next to keener building which houses the homeless men bused in from the bowery by the volunteers of america. omar videotaped again. sarah photographed. and i knotted. it was a very calm and productive day with no visitors to talk with and nothing very much on my mind. a pleasant passing which has lowered my pulse rate considerably.

and now with perhaps one third of the knots installed and my nerves soothed incredibly, i am ready to spend some real time here next week. longer days of tying, but also time in my cell to think and write. and sleeping in that tiny empty and totally anonymous space will help me to concentrate all of my energy on what i am doing and especially on why. so i returned my working things to the staff house and touched around all of the walls with healing oil/water to ready my room for my stay.

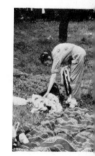

6/16/80

first thing after getting out of my car i was greeted by some patients who wanted to know what i was doing with the knots and why. since i hadn't started working for the day, and i didn't remember having seen these particular men before, i was surprised. i asked them how they knew it was me and they told me that they had been watching me for days. one was an old sailor and talked about safety and utility knots. i told him that the only real knot that i knew how to make was a granny knot: a backwards square knot which we used to tie our girl scout bandanas. the other one just stared at me until he noticed my spider pin. then he told me that he had once had a very long conversation with a spider who told him all of the essential truths of the universe

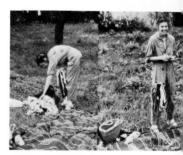

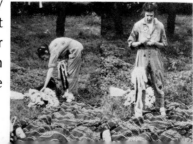

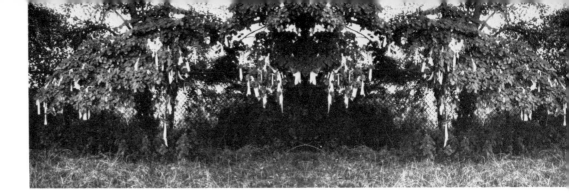

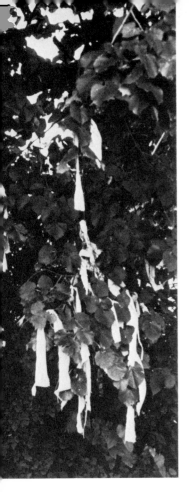

and how the world works. and i told him that i had had exactly that same vision.

the rest of the day was spent in tracking down and talking to the head of the maintenance department about the cutting down of the knotted branches. he investigated for me and indeed it had been his men doing their pruning. they had seen the knots but they had just assumed that it was a patient making them, so they hadn't hesitated to saw them off. we had a consciousness raising session then and he promised to protect the knots.

6/17/80

this time i've come to stay. for hours i sat out on the rocks at the water's edge thinking about how in south america the indians take their crazy ones to sit the day by the edge of a stream. the really bad cases stay for two days.

i started to work on some branches which line the back fence of the

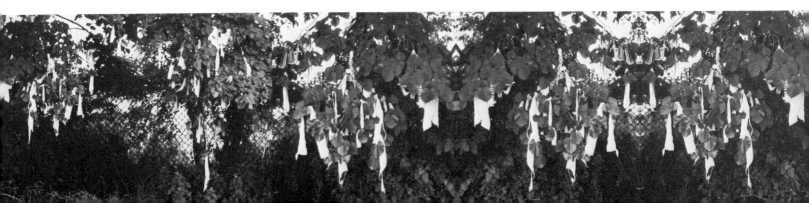

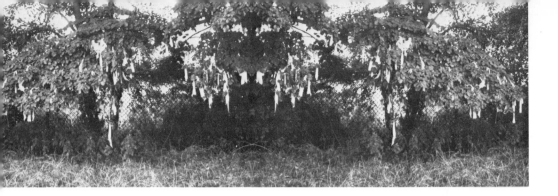

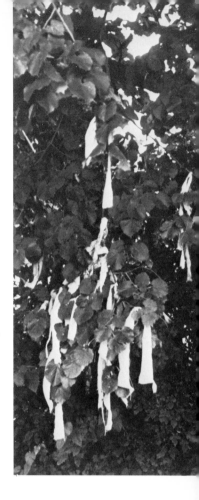

hospital grounds and continued to watch the water through the leaves and knots. it got quite chilly and i moved to a small mimosa tree in front of meyer building where it was warmer.

i think it's important to knot a tree within sight of each of the hospital buildings for the benefit of the majority of the patients who are not allowed out. some men i was talking to last week came over to find out what number i was up to. some others came over to ask questions and i roped them into helping.

when i used all the strips i had with me i decided to stop for the night. on my way back to my room i found and photographed some more knots of my friend.

i sat in my room for the rest of the evening, feet propped up, eating peanut butter and cheese crackers and tomatoes, watching the sun set over manhattan.

and thinking. the more i work the more i realize that it's not the knots that are the piece. it's all the stories. and simply tying the knots is meaningless to me unless i can understand all of the details of the process of tying them. besides becoming clear about the more general mystical anthropological psychological and artistic ramifications of this project, i need to be crystalline about my personal reasons for steeping myself so deeply in it. i keep feeling that there is something here for me to see: something about myself that is mirrored in this environment and held up to my face: something i must learn to face.

it becomes clearer constantly. it's about a confusion of definition and classification and categorization and labels that never quite fit. it's about the classic sort of agony/ecstasy of the seer/seeker whom everyone relates to yet who never really belongs anywhere, at least not in any set set. it's about my apparent karma to be a connecting force processor: a trancemitter who must always pass along everything in order to get (receive/perceive) anything. i'm a regular johnny appleseed of the aquarian age it would seem.

the patients talk to me and trust me and remember my name. they find me delightfully and comfortingly mad and easy to relate to. they somehow know that i will understand what they say and won't be em-

barrassed by it. like the fellow who learned all about life from a spider. how could i find that strange or crazy when i had the same experience? when the totality of my orientation and work comes from my vision of spider woman who showed me exactly how everything comes together, how everything is related: the way of connectivity. now does he talk like that to everybody or did he recognize me and somehow know that i would know?

it's such a pleasure to work around these patients because they are so open to the other world. and when they ask me what i'm doing and i tell them, they know what i mean. i finally found my milieu! great.

but then the doctors talk to me too. they treat me as an equal intelligent sane normal professional together person. they talk to me of their despair and frustration at working in a human warehouse. they complain and then they ask me advice. at least they are questioning spiritual concerns in considering a new approach to healing.

and i even have a jocular running rapport with the security guards and non-professional staff who are considered to be lazy uninterested and sadistic by patients and doctors alike. they bitch to me of their no-thanks jobs and we relate well in a street corner way. they too follow my progress and help me work and tell me stories.

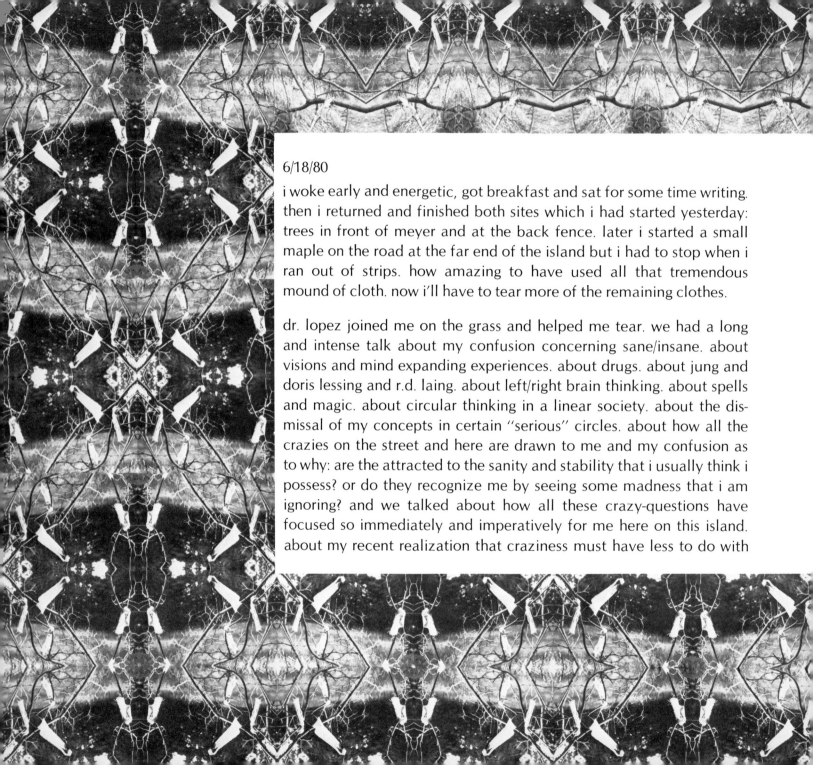

6/18/80

i woke early and energetic, got breakfast and sat for some time writing. then i returned and finished both sites which i had started yesterday: trees in front of meyer and at the back fence. later i started a small maple on the road at the far end of the island but i had to stop when i ran out of strips. how amazing to have used all that tremendous mound of cloth. now i'll have to tear more of the remaining clothes.

dr. lopez joined me on the grass and helped me tear. we had a long and intense talk about my confusion concerning sane/insane. about visions and mind expanding experiences. about drugs. about jung and doris lessing and r.d. laing. about left/right brain thinking. about spells and magic. about circular thinking in a linear society. about the dismissal of my concepts in certain "serious" circles. about how all the crazies on the street and here are drawn to me and my confusion as to why: are the attracted to the sanity and stability that i usually think i possess? or do they recognize me by seeing some madness that i am ignoring? and we talked about how all these crazy-questions have focused so immediately and imperatively for me here on this island. about my recent realization that craziness must have less to do with

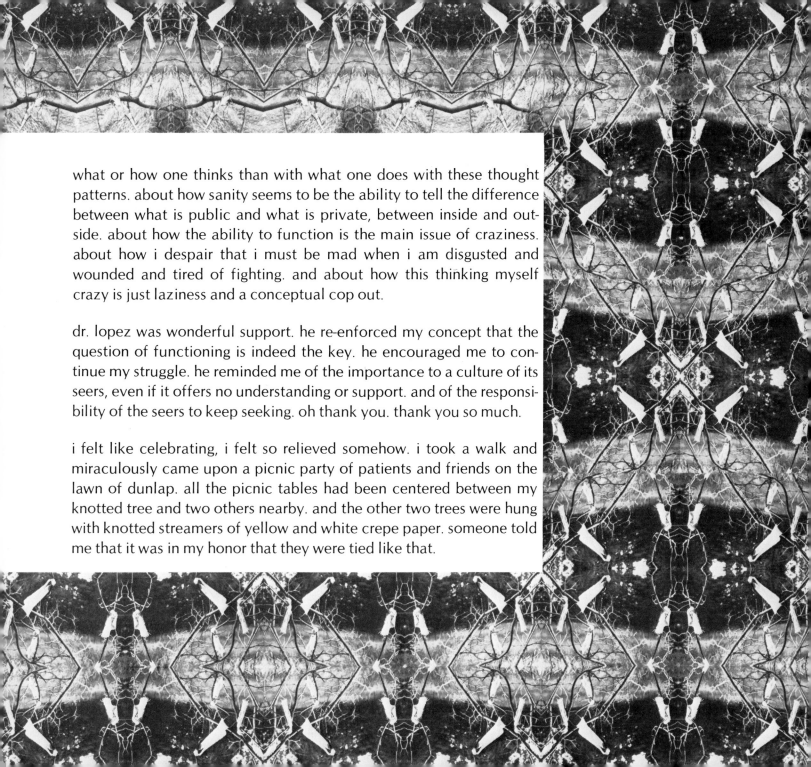

what or how one thinks than with what one does with these thought patterns. about how sanity seems to be the ability to tell the difference between what is public and what is private, between inside and outside. about how the ability to function is the main issue of craziness. about how i despair that i must be mad when i am disgusted and wounded and tired of fighting. and about how this thinking myself crazy is just laziness and a conceptual cop out.

dr. lopez was wonderful support. he re-enforced my concept that the question of functioning is indeed the key. he encouraged me to continue my struggle. he reminded me of the importance to a culture of its seers, even if it offers no understanding or support. and of the responsibility of the seers to keep seeking. oh thank you. thank you so much.

i felt like celebrating, i felt so relieved somehow. i took a walk and miraculously came upon a picnic party of patients and friends on the lawn of dunlap. all the picnic tables had been centered between my knotted tree and two others nearby. and the other two trees were hung with knotted streamers of yellow and white crepe paper. someone told me that it was in my honor that they were tied like that.

toward evening it started to get quite cold and windy so i settled into my room to finish the cutting. it's funny that people chose to tear first what was most easy to tear. and now so many clothes in the remaining pile are synthetic fabrics which have to be cut. there are alot of darker colors too. alot of blacks and dark blues, deeper tones and heavier fabrics. but still no bright colors.

this single bed lures me.

6/19/80

i had a hard time waking up this morning. i feel lazy and drained and somewhat on edge. i feel so immersed in this place, with these people. and i'm so full of so many stories. i carry them around in my bag.

while i was working on a fallen dead tree in a meadow a doctor approached with his camera to take pictures. he had the unbelievable nerve to ask me to pose nude covered with my rags. i screamed that first of all it was a dumb idea. second, i am a guest here. and third, he works here. he's crazy! but then he's the doctor.

i'm beginning to feel a real pressure to finish these knots already. this project has become my life's work. i haven't thought about or done

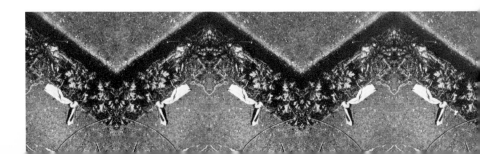

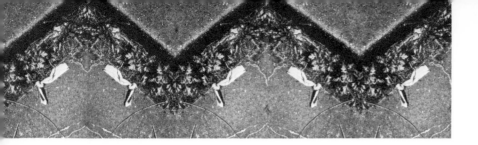

anything else since i started. and the reason that it's going so slowly is all these conversations that i've been having. but of course i have to keep having them. it's the whole idea: this energy trancefer. so then i get impatient with my own impatience.

but i realize that i can't keep staying out here at night. the immersion is getting to be overwhelming. especially since deciding that the bottom-line-deciding-factor of sanity has to do with the willingness and ability to relate to the regular world: to function: to cope. staying too much on this fantasy island would be an excuse for not dealing with my own survival.

all afternoon i worked like a demon, not stopping to rest or eat. when i first conceived this involvement, i assumed i should fast. but once i spent some time out here i realized that i needed to be very weighted and grounded. otherwise, this confusion would overcome me. also my concentration needs to be very extroverted and fully conscious. i cannot allow myself to fly off here.

i did two small roadside bushes. i did about 700 knots and i still felt like continuing. then i got a sudden and desperate urge to leave immediately. it was impossible to deny so i left just as the sun was setting. i almost felt as if i had escaped.

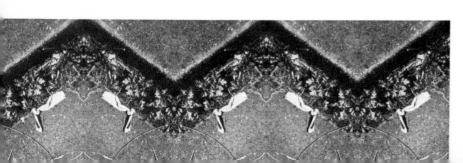

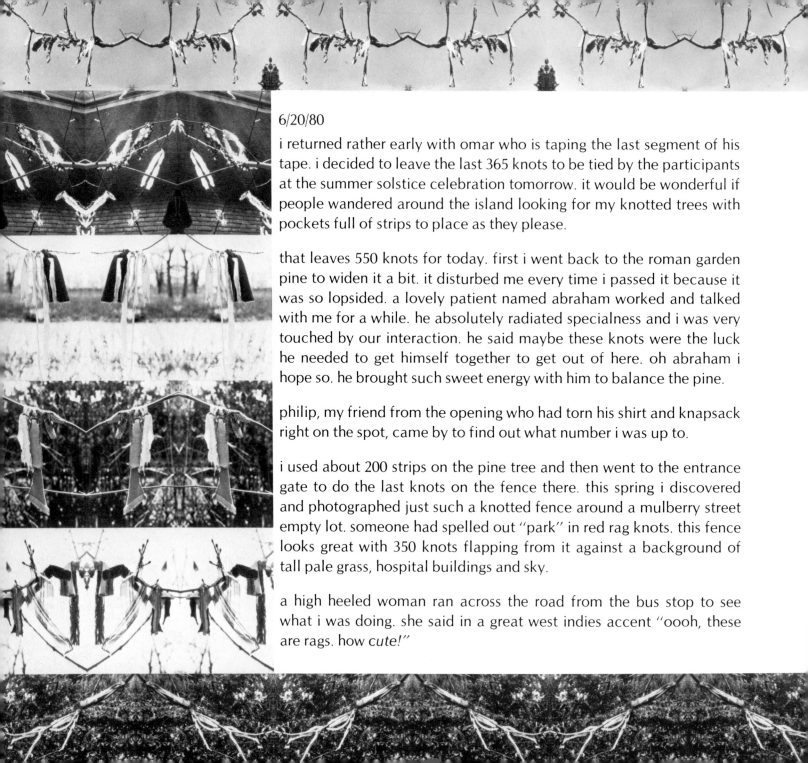

6/20/80

i returned rather early with omar who is taping the last segment of his tape. i decided to leave the last 365 knots to be tied by the participants at the summer solstice celebration tomorrow. it would be wonderful if people wandered around the island looking for my knotted trees with pockets full of strips to place as they please.

that leaves 550 knots for today. first i went back to the roman garden pine to widen it a bit. it disturbed me every time i passed it because it was so lopsided. a lovely patient named abraham worked and talked with me for a while. he absolutely radiated specialness and i was very touched by our interaction. he said maybe these knots were the luck he needed to get himself together to get out of here. oh abraham i hope so. he brought such sweet energy with him to balance the pine.

philip, my friend from the opening who had torn his shirt and knapsack right on the spot, came by to find out what number i was up to.

i used about 200 strips on the pine tree and then went to the entrance gate to do the last knots on the fence there. this spring i discovered and photographed just such a knotted fence around a mulberry street empty lot. someone had spelled out "park" in red rag knots. this fence looks great with 350 knots flapping from it against a background of tall pale grass, hospital buildings and sky.

a high heeled woman ran across the road from the bus stop to see what i was doing. she said in a great west indies accent "oooh, these are rags. how *cute!*"

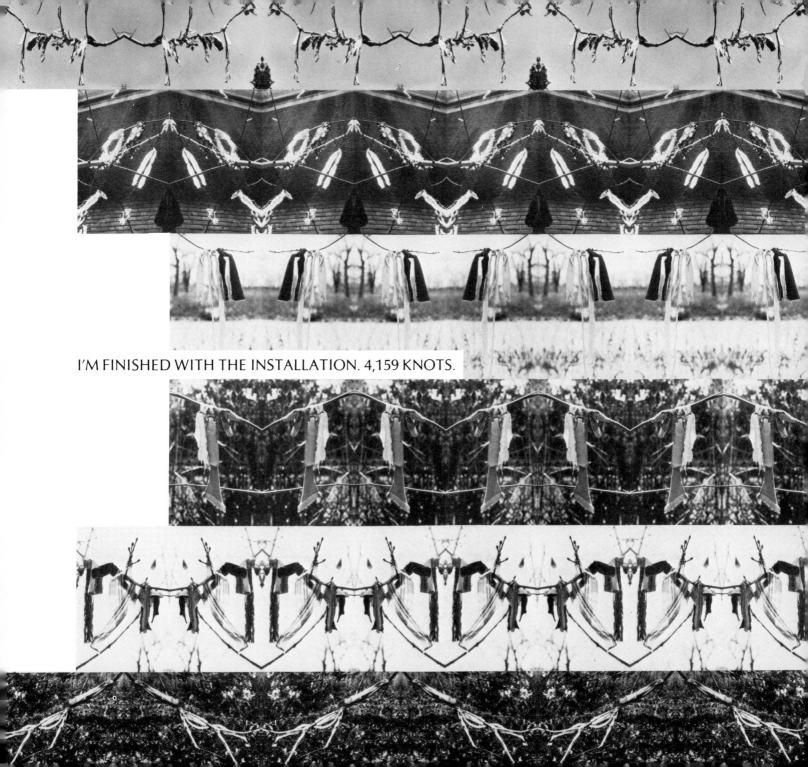

I'M FINISHED WITH THE INSTALLATION. 4,159 KNOTS.

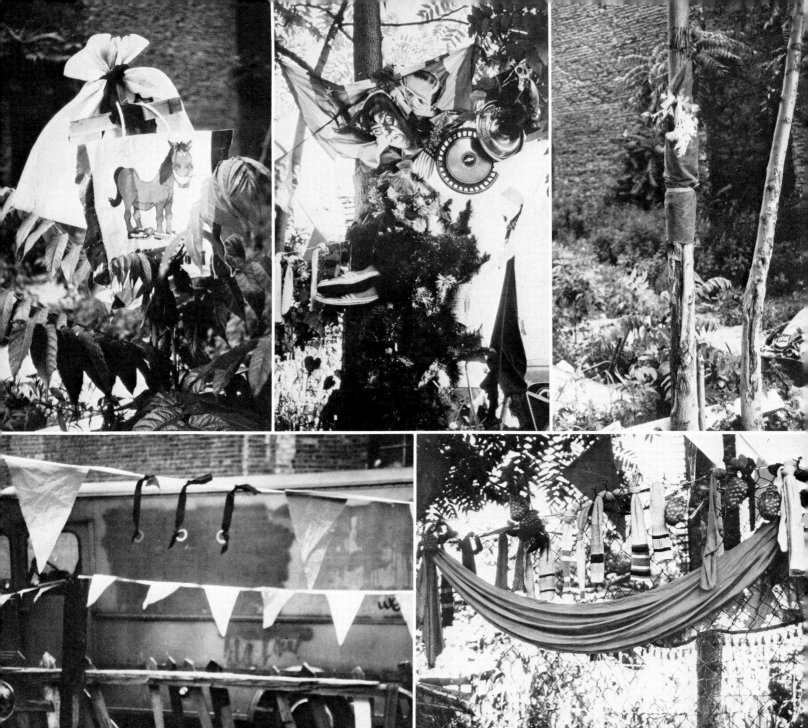

knot lot. 118th street and lexington avenue, manhattan.

driving home from the island i saw an amazing sight which was certainly an omen of affirmation. on lexington and 118th street we passed a densely decorated empty lot hung with hundreds of knots of every conceivable kind. wires were strung across the yard which supported ribbon, flag, sock, banner, rope, shoelace, necktie and tinsel knotted streamers.

i screeched to a stop and jumped out to investigate. this positively charming but definitely weird man had accomplished the most fantastic bit of environmental art that i had ever seen. it was certainly more inspired than any of the sculpture on ward's island. i told him that it was a magnificent altar and he was thrilled that i knew what it was. he showed me what he considered to be the main high altar which he called the stairway to heaven. it was a brick-constructed staircase covered in brown carpet and leading up to several angels surrounded by xmas wreaths.

he told me it was to celebrate the puerto rican festival of saint john's day: the first day of summer: the summer solstice! hallelujah, brother.

6/21/80 DREAM (at home)
a bum stops me and asks me to do something for him. i refuse saying i can't do it for him. he asks in a very exasperated way "well, what am i supposed to do?" i reply "i don't know what you are supposed to do. how am i supposed to know?" then he asks "well, what do you do?" and i tell him "i do a lot."

6/21/80

philip was waiting for me this morning with a bunch of flowers. he didn't know that today was the summer solstice. he certainly couldn't know that the reason i arrived here so early was to pick flowers for the solstice celebration. *this* was obviously the celebration.

abraham also came by early to check in and rap. he honored me by performing his moslem morning prayers on my blanket. and i tried to

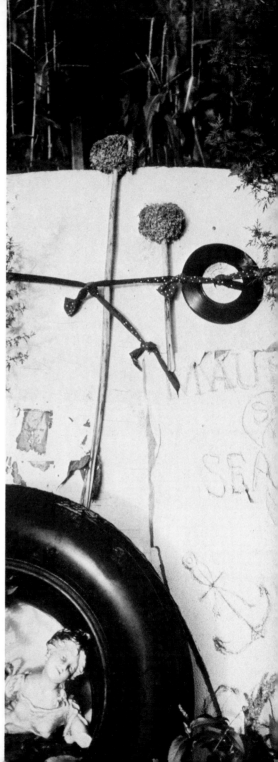

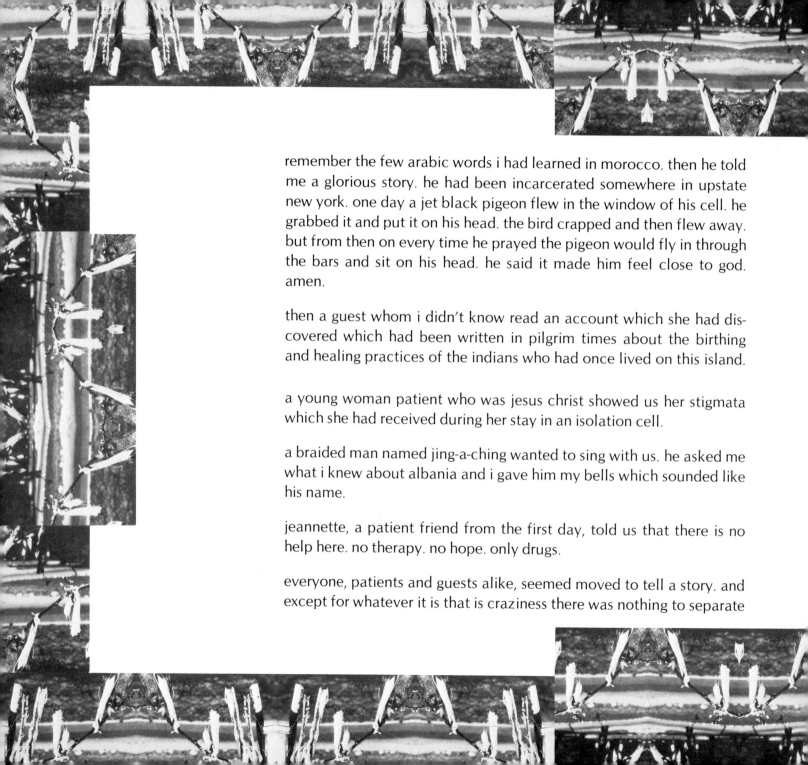

remember the few arabic words i had learned in morocco. then he told me a glorious story. he had been incarcerated somewhere in upstate new york. one day a jet black pigeon flew in the window of his cell. he grabbed it and put it on his head. the bird crapped and then flew away. but from then on every time he prayed the pigeon would fly in through the bars and sit on his head. he said it made him feel close to god. amen.

then a guest whom i didn't know read an account which she had discovered which had been written in pilgrim times about the birthing and healing practices of the indians who had once lived on this island.

a young woman patient who was jesus christ showed us her stigmata which she had received during her stay in an isolation cell.

a braided man named jing-a-ching wanted to sing with us. he asked me what i knew about albania and i gave him my bells which sounded like his name.

jeannette, a patient friend from the first day, told us that there is no help here. no therapy. no hope. only drugs.

everyone, patients and guests alike, seemed moved to tell a story. and except for whatever it is that is craziness there was nothing to separate

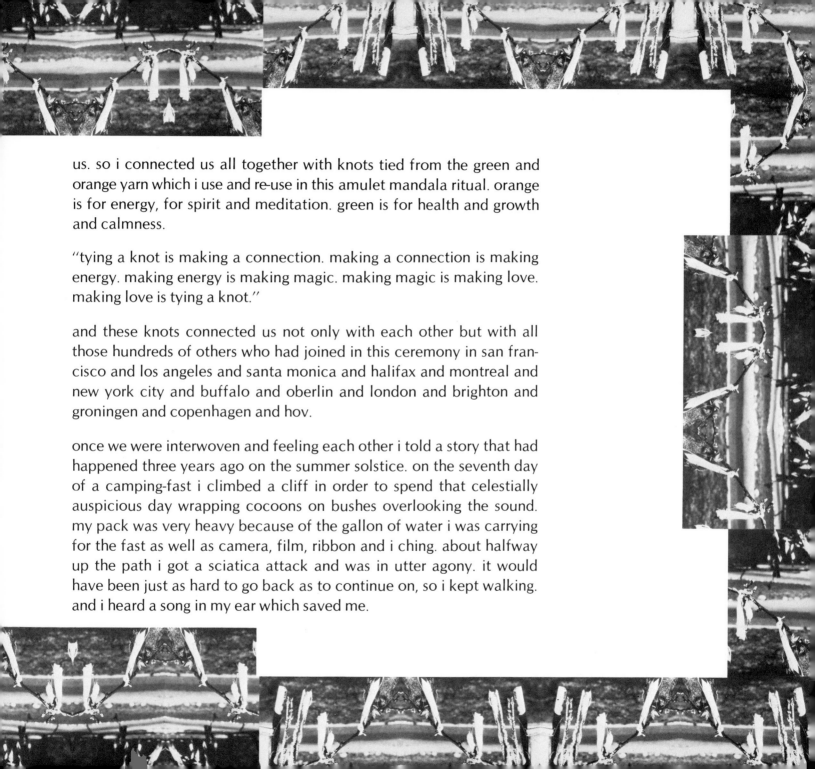

us. so i connected us all together with knots tied from the green and orange yarn which i use and re-use in this amulet mandala ritual. orange is for energy, for spirit and meditation. green is for health and growth and calmness.

"tying a knot is making a connection. making a connection is making energy. making energy is making magic. making magic is making love. making love is tying a knot."

and these knots connected us not only with each other but with all those hundreds of others who had joined in this ceremony in san francisco and los angeles and santa monica and halifax and montreal and new york city and buffalo and oberlin and london and brighton and groningen and copenhagen and hov.

once we were interwoven and feeling each other i told a story that had happened three years ago on the summer solstice. on the seventh day of a camping-fast i climbed a cliff in order to spend that celestially auspicious day wrapping cocoons on bushes overlooking the sound. my pack was very heavy because of the gallon of water i was carrying for the fast as well as camera, film, ribbon and i ching. about halfway up the path i got a sciatica attack and was in utter agony. it would have been just as hard to go back as to continue on, so i kept walking. and i heard a song in my ear which saved me.

i sang it for a while and soon we were all chanting together: "slow. slow take it slow. slow. slow take it slow." and then with our hands joined, our eyes closed, our spirits soaring: "you can heal yourself. you can cure yourself. you can help yourself. you can mend yourself. you can send yourself. you can make yourself. you can let yourself. you can take yourself. slow. slow take it slow. you can warm yourself. you can warn yourself. you can calm yourself. you can free yourself. you can serve yourself. you can change yourself. you can name yourself. you can save yourself. you can show yourself. you can share yourself. you can hold yourself. you can need yourself. you can hear yourself. you can dream yourself. you can dance yourself. for yourself. by yourself. you can love yourself. you can love yourself. you can love yourself. you can love yourself."

it was a long time before we landed again on this planet. we all knew that we had made something terrific happen. we couldn't leave the web we had created. we felt utterly connected forever. but eventually we did separate and we each took the knot which had joined us. and wearing that knot until it falls off by itself will continue our bond and keep our energy activated.

6/22/80

i returned on a whim today to take some pictures. all of the patients who had participated in the ritual yesterday were assembled and waiting for me. they were still wearing their knots. we all were. some had even brought along friends to meet me. this was absolutely stunning because i hadn't known when i left my house this morning that i would end up back here. it was as if the threads that had joined us had never been broken.

they all talked about what a meaningful experience it had been for them. they offered me feedback and affection. and when i was ready to leave for the last time, we made a pact never to see each other again on ward's island.

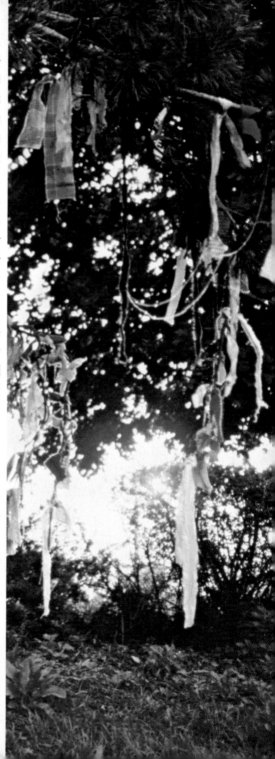

sometimes professional acknowledgement, no matter how respectful and apprecia-
tive, is not enough. every person who touched this book extended such sincere
dedicated positive energy: the same energy with which other people donated their
favorite clothing. may this network of care continue.

PRODUCTION CREDITS
design — Donna Henes / Sarah Jenkins
production manager — Linda Nishio
paste-up — Linda Nishio
black and white printing — Sarah Jenkins
black and white composites — Cloyd Jacoby, Jenkins Photographics, Los Angeles
color printing and color composites — Wally MacGalliard, Frank Styduhar,
 MacGalliard Colorprints, North Hollywood
composite retouching — Laura Glusha, Ilona Granet, Sarah Jenkins, Christy Johnson
printing — G.R. Huttner, Burbank
printing supervisor — Tom Mathis
typesetting — Frances Thronsen, Tin Roof, Los Angeles
halftones — G.R. Huttner, Burbank
color separation — Reco Color, Burbank
other photographs — Carla Liss (Cloutie Wishing Well, Black Isle, Scotland)
 — Donna Henes (Oasis, Sidi Harazem, Morocco; self portrait; patients' knots;
 knot lot, 118th street)
consultation — Frederick Abrams, Susan King, Francis Shishim

we also wish to thank Linda Frye Burnham, Sue Dakin and Jan McCambridge for their
invaluable advice, encouragement and assistance.

the original Ward's Island installation was co-sponsored by Manhattan Psychiatric
Center and the Organization of Independent Artists.

NUMEROLOGICAL JUSTIFICATION
Dressing Our Wounds In Warm Clothes (=9) measures 8" x 9" (72=9); numbers 72
pages (=9); is set in Oracle (=9) type; 12 point with 15 point leading (27=9); and is
being first printed in 1982 (the year in a 500-year cycle when the 9 planets line up).